REMEMBER ME, WHISPERS THE DUST

To [name]

with all good wishes.

All Art is a window
through which we can
see Something bigger
than ourselves.

[signature]

Remember Me, Whispers the Dust

Poems

JAMES SCOFIELD

2003 · FITHIAN PRESS, SANTA BARBARA

This book is dedicated to

Christopher Ricks

Professor of English

Boston University

Published by Fithian Press
A division of Daniel and Daniel, Publishers, Inc.
Post Office Box 1525
Santa Barbara, CA 93102
www.danielpublishing.com

LIBRARY OF CONGRESS CATALOGING-IN-PUBLICATION DATA
Scofield, James.
 Remember me, whispers the dust : poems / by James Scofield.
 p. cm.
 ISBN 1-56474-414-0 (pbk. : alk. paper)
 1. Death—Poetry. I. Title.
PS3569.C583 R46 2002
811'.54—dc21
 2002006933

CONTENTS

PREFACE

The principle challenge facing contemporary poetry is self-delusion. Illusions abound. Because the number of people involved with poetry is large, its participants believe their poems are a relevant part of the culture. In fact, poetry has lost its most important audience—the millions of intelligent, well-educated, sophisticated people who are not a part of the professional world of poetry, yet remain devoted to the other arts.

MFA programs and magazines such as *Writer's Digest* and *Poets & Writers* cultivate the illusion that anyone with sufficient instruction can become a poet. In fact, we have rarely seen more than a few true poets in any one generation.

The hard fact is that right smack in the middle of contemporary poetry is a giant mass of mediocrity, writers with no interest in a long study of the older poems, or craft, or patience. Collectively they have suffocated our best journals, submitting tens of thousands of manuscripts to each, and the journals have responded by printing the best of the worst.

A new Renaissance in poetry will recognize that the poet must put his ear close by himself and hold his breath and listen. That it is time to be quiet for a while, to sit with one's hand on one's mouth; a long, austere, Pythagorean lustrum. This new age will cherish poets who survive in a single line.

Once again rhyme and rhythm will measure the latitude and opulence of poets. Rhyme will again be seen as the correspondence of parts in nature, acid and alkali, body and mind, character and history, action and reaction; that rhymes to the eye, such as shadows, explain the charm of rhymes to the ear; that the inner life also has its rhymes, perception and expression, ebb and flow.

Then poetry will no longer warp away from life, and its test and measure will be its power to transubstantiate the world, to convert into universal symbols the energies acting at this hour in New York, in Chicago, and San Francisco. We will be able through subtle and commanding thought to read the poetry in affairs and fuse the circumstances of today. The tongue of the people in the mouth of the scholar will be the motto for the new poet.

Today's poets do not ripen well. They lack severe standards. They have no sound thermometers for gauging their talents. There are certain things that are good for nothing until they have been kept for a long while, and some that are good for nothing until they have been long kept and used: wine, meerschaum pipes, violins. A poem is like a violin, the parts of which are strangers to one another until they have learned to vibrate in harmony. A poem is as porous as a meerschaum; in order to be good, it has to absorb the essence of the poet's own humanity. The poet must learn to keep poems until their sentiment harmonizes with all the aspects of the poet's life and nature, until he has contrived to stain himself through all its thoughts and images.

To not do so is to write poems no one can remember, as if they had been written in water.

J.S.

REMEMBER ME, WHISPERS THE DUST

BIRKENAU

I.
disembarking the cattle car

my memory is well broken

I try to gather a few memories but
they seem halted by a hedge of time still

80 of us we stood 4 days peering
through slats 2 buckets no room in that tin
box for women or children to rest their heads

you must bear with me those times must be built up
I am albert grinholtz that much is sure
my wife rosa our daughter ala taken
we were when the trellis was full of early roses

5 by 5 they marched us out an orchestra
played what? then I knew I remember our
old men tipping their hats we marched barbed wire
tall stanchions bending towards us guards humming
March little shoots everywhere discharging life

I saw inside a car a puppy they
had been trimming trees the buds were dumped
stacked lying in heaps so many children
the sky low soft a rosy hue lovely
that's my girl over there on her tip-toes

2.

remember me, whispers the dust

there was a man staring at my ala
a herd of naked gypsy girls passed by
ala blushed this man began to laugh he roared
with glee I shook my head hard but ala
stuck out her tongue someone whispered, "mengele"

at home Sunday smoke quiet streets sitting close
to stoves bread in the ovens one morning
they hanged a boy too light he was and took
too long to die a lesson another bout
of efficiency their sincerity is shattering

18 hour days so little food our eyes
grew dull veiled we could see through our skin
thin papery rosa my lovely wife
who never raised her voice screamed at a guard
his eyes they were as dark as an old lake

she is before my eyes still her trampled
trunk dragged by the dead hair gone touched by them
now unreachable no birds now no butterflies
only beetles crawling on the backs of the dying
life feeds on life no fiddle, no books nothing

the children mad with hunger yesterday 3
broke into the morgue cut off a buttock
and ate now 30 rammed into a shed
another lesson my ala there we
all pray to a heaven steeped in darkness

2 days so very hot too weak to scream
soft sounds scratching once I heard such sounds
a sealed bucket of water full of kittens
to the other children they give to each
a piece of candy no not yesterday

today I have no home here during the rains
a waterpipe performs outside the window
a parody of blubbering woe with
funny sobs and gurgling lamentations
interrupted by jerky spasms of silence

THE POND AT NIGHT
for Barbara McMichael

In early spring the watertable rises, splotches
spread, frogs hop out of dirty ditches and line
the virgin shore, leasing the middle to the gulls.
And then the ducks arrive to notarize the pond.
The field, which slept against the sky, wakes, and finds
a new tide rhythmically preaching doctrine to the grass.

The night is coming, already hugging the big trees.
The sky is now a low roof, the black pure and deep.
A long and tall fog line shuts out the setting sun,
orange-yellow streaks struggle through corrugated breaks.
The sun burns down, the ground gives way, and the day is gone.
The ducks drift, puffs of wind disturb feathers, water,

And then the frogs begin a jarring chorus that rips
my ears, the highs and lows filling a grave-browed night.
The path into the field retreats, cut off, buried.
The water's night polished with a glooming light, sinks
staggers down to the stone bottom, then gives way to
a deep blue-black beyond, a thing vivid and senseless.

The wind has lost its strength, diffused in empty space.
Shapes brood, shatter, angles shiver, jumping high
a lovely woman tapers off into a fish.
A thing, long legs stretched back drops in...a deep clucking.
The heron profiled night plucks, devours the last light.
And grief at long hard last breaks a way for the voice.

TWO SEASONS
for Ted Roethke

Winter, stalking like a crane, cold stitched on bone,
a fume of decay, creeps up, stretches and reaches…
Light thickens; disaster climbs the vine; the trees
no longer hold the light. A nestling sighs.
A time of long-standing understandings.

The light comes slowly over the white snow,
the sun cuts deep into the heavy drift,
below the cold roots stir; a scurry of warmth
over small plants. The dead don't hurry, but
the days move in a slow up-sway; a path
goes walking, kisses come back, the dirt's lonesome
for grass (as shapes in the shade watch and wait).
For John-of-the thumb's jumping; a Mallard
has come to stay; I see my heart in the seed!
Sing, sing you symbols! Bless me, and bless the weed!

THE FIELD

The field is the land we cross until it ends;
a geography of the living and the dead.
The maker of a thing yet to be made.
The years move on across our every wish;
all is final, but endless are the mornings.

The morning light comes tapping, searching for sound;
a long weed floats upward, stiff stems jointed
like corn stir, cold kept sleep shakes out a subtle
musk, a fume of ripeness. Some morning
thing comes beating its wings, I hear singing.

The sun ignites, stem-fur days, it's time to begin.
The warmth spells promise, freeing all things
that have survived. My hands twinkling with wet
trellis the sun; the wind braids around half-buried
flowers, blown over and over themselves.

I walk around the edge, my candle burning
its socket, time's nerve in vinegar. The field
is my wound, my light, my parched and raging voice.
Youth condensed here, and sixty seasons
followed; it is love's house, and death's thorn.

Life rips the bright flesh away, a rhythm we
cannot break; when any light goes out, life
is death; we move as the water moves, cloven
by sullen swells, shoving and slithering,
till field and grave lie level and the same.

Upon the field the scent is dry; the grass
now wears the pure poise of the spirit; the ferns,
the birds, the mice, and the deep shade, all wait.
My slow breath thickens on the air, time to
put off the world and go into the field.

THE BEAR

*"In the Middle East, the bear is an endangered species
only because of abuse."*
—*World Concern for Animals*

The bear is forced to dance, a chain through its jaw.
His partner a swollen shadow on the wall.
The man who holds the chain is a dark law,
and round and round he spins the bloated face.
The bear is sick with a fear that has no form.

There is a place, some know it well: hate
to left, and right to death, and there you are.
There we came shyly through the garden gate,
and young hope ripened for an obscene grave.
And there the bear found man and began his dance.

One night, too sick to be ashamed, his face
torn open, haunches trembling, he begged for food.
Ignored, he sat, his funny hat in place.
Light gone, dragging death with him to his cage,
he went to sleep, wrapped in his funny bag.

Later, he heard the night pick his bones in whispers.
Dawn broke open like a fresh bleeding wound.
That night a field rat came close chanting vespers.
Time done is as dark as are sleep's thickets.
Men came, and one said, "Drag him into the sun."

GINGER

She was a crotchety old gal, hard bred
with booze bad words and Camels; a cast-iron
lowbrow tail-swatting mean-eyed pill-spitting
orange-black stumpy slummy apartment cat.
And I loved her. And yesterday, she stumbled.

There is no rest. Somewhere? Maybe. But
not here, today. Today is all we have,
and through each yielding day we float and bob
storms moon and dawn, upon a fate-obeying
enormous sea, gloomy mad, and silent.

I had waited too long. Too weak to walk,
bearing her weight, I took her to the car;
quiet and cold we drove to where it would be done.
It took too long. At night she would snore like
a child in pain. The drug seeped in, puzzled

she looked at me, snuggled into her blanket,
and made that sound. Then the vet lifted her
up high—she hung like meat off a hook.
A long needle slid into her belly; soon,
the dark came on, and took away that sound.

THE FIRST TO DIE

High up, in a blue sea of sky, above
the first firm hour, tides of fire still and cold,
below the pride of the stars, the first hawk flew
over the dark mountains, down long black valleys,
below his wings the quietness of stone.

The center moved—a soft thunder from a
wrestling daybreak; rising shyly, he flew
through a light soon to be called morning.
All things were like flowers, walking towards the river
of the sun—an earth of dreams, so new, so changing.

And change there was. As his talons grasped
complete the crux of rays, a brutal vision
flashed within—and there stood Man, too little
removed from mud, shearing between life and death;
Man single in the crowd, with shit-patched skin.

And then the hawk saw slime within the skull;
dead leaves beneath the trees; hawk-faced prophets;
wrath and laughter; the innocent air perverted
into assassin and poisoner; and then
the sun dying blind and blacken to the heart.

His heart burst, blood flooding, raging, wallowing
through his wings—his eyes closing he dropped
down down and around, but down, into dirt.
And the wild God, intemperate and savage
contemplated the centuries of broken bodies.

BEES

Sometimes the swing of nature must be stopped.
For days the bees have been stinging children.

So, at dusk, as they came home, day finished,
I put on latex gloves, shook the bee-bomb twice,
and sprayed pure white foam into their hole:
Tetramethrin and Cyclopropanecarboxylate.
They struggled, furiously; latecomers, knowing
no where else to rest, flew into the foam.
Shaking themselves hopelessly, they died.
The sound I heard was the crackle of foam.

Morning. It was 10:15. I sat next
to my purple daisies, pink lilies, poppies,
the hole ten feet away from where I lounged.
Without a sound bees came out, drifting up,
perhaps ten feet, and each was white, a tight
tiny white cloud, like frost in sunlight.
The cloud crumbled, settled slowly, a trembling
falling shape, empty, frittering downwind.

One bee, still yellow, flew to the sidewalk,
dropping at my feet, its body writhing, weltering
unconscious into whiteness, its wings up.
A tiny ant came up to it, circled,
lifted the bee's butt, as though to make it fly,
then crawled away, front legs swinging blindly,
wiping its mouth, bewildered, staggering back
to balance, hot flesh tenting up it died.

I lie on our bed, your face by mine, April
wine and sun and sex flaring hot.
Shadows merge, we sift the layers saved
over the years, their diamond-pointed mercies
like timeless rain. Hot blue high clouds pile;
soil and water alive on each other.
Who wins who dies? I must not keep forgetting.

I sleep you frown, why? Long legs are lovely.
You butt me, cry out for mother, hurt wild
like a child in dreams. What was is other things.
A thousand baby bees swarm the sky;
all things seen by the naked eye, when closed.

VACATION

These happy days that refuse to go from yes
to no; days that sit, preen, and doze, and know
the convolutions of the simple wish.
Myopic days, where fate is always late,
and not a tick of time is heard—these days
have ways, like those lovely women we adore,
but do not trust, and yet, cannot ignore.

Well fed, lucky in bed, you find your face
in a pool of grace. Under the spell completely,
basking serenely, never sick, never
quick, never stronger, but younger and younger,
you see the week is falling fast and the
flowers will not last, and then in the end
around the bend you see Monday with a grin.

IN A SEEMING SEAMLESS SUMMER

In a seeming seamless summer I wake
asleep, and begin to walk beyond the shelter
of the mind. Into the field I go, the knolls
burned brown, but undulations still supple
and turbulent, though now the deep songs froth.
A small red blossom agitates the shade;
sweet berries ripen in the hollows; the bees
articulate the clover. Past the jangle
of doom, the jumble of words, enjoying the
dependency of day, alive with age.

An aging afternoon, the winds of change
blowing strong; I pass the skin of a snake,
black and brittle. Sharp voices cry, dreams
a monotonous babbling, pain killing pain.
There is no such thing as innocence in autumn.
Bending against the invisible, I pass
beyond belief, past the vulgate of experience,
the intelligence of despair, past the thought at
the end of the mind, into freshest, brightest fire,
to find the cat's milk dry in the saucer.

CLOUD FACES

First a Queen,
Then a Devil;
An old Queen,
That old Devil.

And now a carrot,
Or a cucumber;
For the old Queen,
From the old Devil.

And now a cigarette,
the queer light on her hands;
as he travels backwards,
an ancient promontory.

A formless form on a formless plain,
That was and is and comes again.

THING

Each day thing is there. A hinge between
good and bad; behind us, waiting ahead,
it sits when we sit, sags when we sag.
Between each pause, behind all silence,
falling with each falling leaf, there is thing.

Lodger inside each rotting tree; clutcher
of each cold gravel road; harvester of each
pretty face; the moving shadows in each
abandoned house; seizer of each cold root;
the tap, skip, tap against my chest, is thing.

Each pure note is a thing inexorable.
Each day, each night, is a thing inevitable.

EMBER DAYS

"Today over one billion people are trying to live on
less than $350 a year."
—United Nations statistic

St. Phillip Bartholomew Episcopal afternoons
 quiet chic

Alice Elizabeth Simon. Socialite.
Summer sailor. Winter hostess. She
dozes with two hundred empty pews,
a jaunty yachting cap inching down

Her Lord, scaled-down by the pollution of time,
lingers; cuffed, ears boxed, dressed down and lynched.
Her sweet Jesus, staring wistfully at
her impeccable white slacks, her tasteful belly

Time out of mind she dreams, a dream that spins,
staggers, shrieks of ravens; just yesterday
her mind, on a routine voyage, remembered
pink bloomers, a world sound and safe, settled

On ground cracked with drought her dance of delicacy
slows, hymnals claw at her, her lamb farts
stirring a history set out in weather
too long; shadows, shadows rising, staggering

Cows plod and stumble, hoofs aching with heat,
their tea cup of milk fevered in the udder.
A sundowning, flammable gold foreboding
beats on their hides, their haunted world receding

A forest of arms, children, reaching for reflections
bellies swollen, eyelids like rags, buzzing
slow-dying lives, eyes a lonely brightness,
surging to a deep hollow-smelling well, empty

To Alice, with her level challenging look,
a stale scent of downscaled expectations.
To them, inching through a boot-battered East,
they are falling, dropping into a bottomless

Naked in her tub, Alice soaks a wounded
pessimism, shivering like an underfed dog,
embattled and ingeniously self-regarding.
Her mouth puckered, she shakes her head, the dream
shakes out, falls into a new order, settled

EDEN

Hony Soit Qui Mal y Pense

(Against that time, if ever that time comes,
 when I shall see thee frown on my defects…)

Sometimes, in that time of year, when cold roots stir,
When, moment to moment, shoots spread, young fruit swells,
And birds, still mated, April pouring out of their throats,
I stop, and think of that faded fable, that time,
That place; where beneath the yawning hugeness of the heavens,
The breath of cherry blossoms exploded pink into the air,
Watery grasses flowed, spring sparkled, and where now
Was forever, time a silky quiet : Old is the idea
That once there was a time and a place called Eden.

That place. Outside the rotation of the seasons;
Yet, to speak of Spring is to see the shadow
Of its beauty. The mornings, color and mist,
As the warm antiquity of self began to grow,
Light giving form to the motions of the mind.
Seraphim arranged above the trees, awaiting
The promise, the sound of the Nameless One,
Coming through boughs that lie in wait. A gentle
Work, joy delighting in joy, beauty
Held in lease. Day flowing in the flow of space;
Then evening, rest and silence spreading into sleep.

(It seems probable that this beginning began with
 a solid, hard, impenetrable, nasty hypothesis…)

The Nameless One laughs and plays, rethreading
Creation's loom; alongside a crystal stream,
Hoc Est Corpus, the birthday of life and love,
 (a myth is as good as a smile…)
Hands, terse and invisible, lift them up, rigid
With delight, the wind blowing in their eyes,
Their souls a sunlit silence, the first born
Singing to them; infants, in an infants
Playground, a clock wedged against their spirits.

Perfection their birthright, the author of unborn
Occasions, the power of possibilities that exclude truth.

 (The great interests of man: air and light, the joy
 of having a body, the voluptuousness of looking…)

He came, gray-green and mighty, across the field
Of time, wild with death, a scream in the morning light,
Crawling between thing and thought, seeking
A primary glance of the Blessed Event.

 (Really, he was indifferent, it was chance
 that played the joke…)

In that always gracious light, they came;
Each in turn in mutual ordering, the future
Like the past present before their eyes. Serenely
balanced, eternity their toys, standing in the gap.
Twisting and turning on the hook of ignorance,
A question tearing them apart, they took and ate.
A sigh. Deep in their chests the weight of knowledge.
A bird pulled a worm as the immaculate season ended.

 (No red hand in the window, no window…)

He came, caressing the faithful roses;
Time saying nothing but I told you so.
The light of morning now immensely ambitious;
How rich life had been and how silly.
The Other left, his successful debut over,

(I smell blood, and an era of prominent madmen...)

Thinking love a subjective fake, and other thoughts
Unthinkable, sliding into the snarl of the abyss.

They stood, the three of them, between them a wall
Of offended silence, the two mad with courage,
The Third releasing the long breath of night.

(And now we have no time not to be gay...)

No hand could hold them, the bud of the apple
Is desire, and to breathe is to fulfill desire.
Quite suddenly He was gone. They caught their breath,
She looked over his shoulder, the light tapering to nothing.

(After the final no there comes a yes...)

No more sweet sleep. The first purple dawn.
Taking only a cup of space, these two, the first
Born of death, the wave of branches good-bye,
Stumbling over rocks as terrifying as the stars,
Looked up, but could not see their faces in the sky.
For a brief, bright instant the centuries lay open,
Before them men weaving the stubborn strand of faith.

INTERVIEW WITH SNAKE

The Snake was still under his wet weed.
He wondered what to say to this naturmensch.
My lame feat of salvation still has charm?
Maybe, sometimes hope lies beneath the ground?
(Last week Iris pushed up ahead of Crocus.)

And so, Snake, eons now since we have had
a word from you—what's up? A bit of humor,
Ah, yes; well; we may have to break away
for breaking news, dog strangler on the loose,
asbestos dumped on White House lawn, you know…

Mosquito news, you ass! a web self-woven,
the burning and blistering strands running
inward; your news, your lives, a flutter from
darkness to darkness. My gift to you was
light, to romp and play through endless fields.

Where violence was spring taking the fields by force,
blooming until all worlds were white desire.
But then came man, drowning out the ordinary
sounds of mystery, man insulated from
the strong earth, yet cold, uncertain, sleepless.

And now, torment lying next to your suburbs;
and your eras of spite and hate-filled half-worlds.
Now night comes, courage and the will are bystanders.
You must uncenter your minds from yourselves,
before you sink, sink down eye-deep with Hell.

We break for breaking news, here is the President:
"Our culture is one continuous moment,
we must never slow down. All war is good,
death is good, not for me, but good for heroes;
the world will cringe and curse, and then obey."

MOGADISHU, SOMALIA
24 December

Sometimes I wonder if God sees, sees what
I see—a central anguish, impregnating
even the innermost atom; this central
fact within the immense disorder of truth.
And though blood blesses the heart, this heritage,
this dry ghost hangs in the brain; no shift
of other realities has changed this truth.
Tonight there are only the winter stars,
but soon the Holy Night, then that doomed Child.
Someday even the old will have forgotten
the cry that blew time to its knees; and now
a silent, brooding Church, always eccentric
to the eye, a tinkling in the ear, a winter
dialogue fading into silence. And then
a generation sealed in a long deep night,
each morning clawing at their beds to
begin again. Does God see these children,
forced to mediate terror, gutted to the crust?
We still run and stagger, and demand to know
why Time is a jerking noose, rotten to its root.
Here only hate is happy; these children
haunt a ruined century; they close their eyes
tugging gently at the night where each was born.

EASTER

We are still young, old John the Baptist, and I.
Two hikers, alone at dawn, ten miles up
the Pacific Rim, somewhere between Tokeland
and Westport, the tide turning, the sun rising.
It is the season for crabs to flip their lids;
and old John, caboose wiggling, white plume
in overdrive, bushy paws splayed, zigzagging
the beach, works his snout from shell to shell.

Shining green and blue, a fish-scale sunrise
crosses the water, dancing through the dark.
And John, happy rather than holy, washed
by a rainbow, chooses this burning moment
to turn and squat, the sun budding on his fur.

I try to rise up to this Sunday idea;
it snaps at my fevers, like John snaps water.
My legs are tired, this surface, little rocks
like lentils, giving way, hard to keep up:
resurrection politics, the game I play
with my life—my marriage is a nest, made of
bits and pieces, the only home I have known.
Some rocks are for holding, easy in the hand,
easy to let go, but these, I keep sliding:
My life built out over a raging river.
Look! John has stopped. Ears up, crouching he
Advances on driftwood shaped like a deer.
And me, have I warped into the right shape?

The sun burning my face, sore back, a log,
old John flopped, panting. Time for water and
dog cookies; John has a jumping spider
crawling over his crossed paws, moving towards
a home half sand, half sun. Here what is real
seems a bit smelly: In our beginning was
a life without sky or horizon, too close,
over big; with what innocence our hands
submitted to the rules, our hearts remaining
true to the lucid gift. Our dream of safety
has disappeared, the lie of our divinity
has been told, and now our hope is to hold
to the ordinary way, peering through chinks in the wonder.

FOR SALE

This little house I remember well.
The white clapboard, the tennis net
tied to the porch.
Firm in its own small, static, limited
orbit—perfectly at home,
over painted, over lovely.
Now this sign; today
things are not well.

There is the camellia bush,
curiously slumped forward,
the leaves whispering; a half-burnt-out apple tree,
blossoming: the apple-flowers
fall, breath on breath
they wander from my mouth
to the ground.

A cluster of garden greens, then the door.
Inside, the floor seems to dip,
rolling with a new bewilderment,
then stops.
Sunlight glints in the air
like worn brass, everything else
crossed with black. A split leaf
crackles on the wood floor.

Two girls
sitting and talking through the net;
two friends
who met here and embraced
are gone. Now
everywhere
only silence.

LOST IN HARVARD YARD

Nature is cramped in Cambridge, Mass.
And so Mike the pigeon
Is known to camp in Harvard Yard.
Old, dirty, and fat,

Chased each day by Maxie Waxie,
That old dog of dogs;
Mike, too fat to fly, could guess
When to trot, or whirl.

One day he watched a lame sparrow
Pinned to the ground by a crow,
Its beak spearing, pecking, tearing.
Catching the bloody mess,

The crow carried the struggling sparrow
Up to a low ledge,
And ate, life feeding on life,
The sparrow flapping, flapping.

Little Midge, a Harvard girl,
Her head nodding like Mike's
Lost in knowledge, wandered across
The Yard, searching hard

For Grandmaw's watch, yesterday lost.
Looking up too late,
A maintenance truck smashed her down,
Stopping on top of her face.

Mike the pigeon, a touch hungry,
Pecked the bloody flesh,
As Midge screamed, cried, and died.
Her watch ticking somewhere.

Old Profs, in black dreams,
Sometimes see Midge,
And her white bloody muddy dress
Flipping in a warm breeze.

Faceless Midge, nodding, nodding,
Searches her seamless world,
For Grandmaw's watch, ticking, ticking,
Lost in Harvard Yard.

ELEGY FOR A HOOKER

a sailor shuffles the night...
considers a ripe, uneasy girl,
smooth and ridiculous
with dirty legs and muddy pantyhose,
her face drifting across the window-panes.

lightly, quickly, she moves away.
he whispers (you sly little bitch)
he rubs his it, holds it,
thick, warm, moist; and then he stops, and listens.
the wind, like the howl of wild dogs in the blow.

they move under flat lusts of light,
with hideous spontaneity,
her pretended breasts bouncing.
the pigeons mark time with their bobbing heads.
the pace of a dog slows, then it squats.

he touches her with his damp hands,
softly singing like an idiot;
in the hot alley he
puts her hair in his mouth and licks her eyes.
above liquid droppings fall from the ledges.

in the room he holds his it and slobbers.
outside a dribbling moan of jazz.
several stars blink open.
and then a perfect darkness fills his mind.
the city sleeps, the hours descend, and crumble.

her eyes, too weak to close, see fists.
she sees him swing, and then he sings.
death licks her belly.
dreams, gone so long, return, falling memories,
that strike, strike like a clock in a dark house.

THE MORAL MAJORITY

Make way!
For a time of perfect irritation.
A pissing match between standards.
Flags waving like baby rattles.
Fagins drawing a daily wage.

Insufficient types, easy, dangerous.
Their brains in uniforms.
Humping a clear but trivial idea.
Discourteous villains in a suburb of prophets.
Wrong, a charmer, dwelling incognito within this hour.

Indeed we must not lose faith, to undo
the folded lie; to know that love, like matter
is odder than we can know; that all flesh
is grass, that, beg your pardon, old ideas
like the June bride, are sore, but satisfied.

THE OVERRAPTOR

It comes after the shadowed days are done
People grow afraid
The shiny white and red barns are gone
The hours bleed
Time spins overhead, and then it comes, searching

The burned wind spins above our empty houses
Tears without grief
Reason lies flaming in the outer darkness
the stars safe
a jawbone goes on with its alluring grin

In the tunnel of the spine it sinks its claw
We piss red
Gargoyle vaginas reckless of blood stare
being themselves nothing
Heavily dosed with death's night we lay astonished

Taste of untruth? Yes. But strange futures can
still lie ahead
If the human way is not kept singular
then for certain
a master will need you for the work you need.

THE LAST YEAR OF AIDS

A Plague
A Torment
Men and women still living
caught
in a horrid rush of ending time
monstrously reduced arrested jailed

Death houses everywhere
No escape
from the frightened law of fear
Vast silent charnels
dim lights hollow glimmering corners
Cures mingle with heaps of bones

One sees the bare ribs of his father
another the hollow skull of mom
stacked up stood up a thousand corpses
rotting apart the stench
filling the dying noses
worms crawling around naked purple feet

From wall to wall they run
They beg to die
In that last year Death
pitched his tent
a heap of winding sheets tacked together
And still this is not Hell.

ON CHOPPING WOOD

First, the ax. No toy this thing, this beast
that holds continuous intercourse with nature.
Now, the wood. Though fresh, green, and stacked,
it could be soft, spongy, damp on the back.
Too little sun! Reach down, flip, grab two good
handfuls, pull up, position, your feet flat
and wide. Now, ready? The ax. Hold it.
Cock the head. Clean? Sharp? Slide your hand
down that hard, smooth graceful stick, it too
is wood. Spread a crack, slam it open! Deeper!
Good-bye yard! Ride, ride that chopping diving
ax, past gladness, bed and breast, hair and bone,
past smirk and sweat into twilight and madness.

THE DRUNKEN BUTTERFLY

My strength is barely Wavering I tumble
past structured notions flight is so fragile
The beak of death misses, nuzzles, By By
Blue Bird; old age is not the loss of sex,
or eyesight, but the loss of parallel-parking.

HIGGINS THE POET

His shoes were shined, his pants were pressed, and so
Higgins was ready for his walk that night.
Inspiration circled overhead, while below
line by line Higgins walked, brimming with insight.

And though some friends said, "Hi," he would not talk.
Sketching in rhyme he kicked at a sassy cat,
muttering, "Now, Muse, now, damn you," block by block;
smiling, she replied, *plip-plop* onto his hat.

A TRAGEDY IN FREE VERSE

A funny thing happened on the way
to our ocean cabin
A terrible accident
three cars, exploding steel
three dead men, perfectly still
twisted, ripped, blood
everywhere
a limb twitching in the ditch.

A three hour delay
A friend approaches two women ahead of us
"Nobody we knew I hope."
"Naw. Just Mexicans."

When we arrived at our cabin
human nature, being what it is
we drank and ate with lust
and I said
"I know you're not there you old son-of-a-bitch
but thank God it was them
and not me."

DEATH

The birds and squirrels will come to take me,
grateful for years of food and water, and they
will usher me into a sliver of light,
just beyond the edge of decanted Blackness.

Within the Black, faces, irresolute,
perplexed by the ghosts of puppies jumping,
just out of reach. The faces live in foul
dug-outs, gnawed at by rats; in this soundless
cellar this world blooms, recedes, blooms, recedes.
The broken pillar of a wing dangles.
Five night-herons fly above the rotting edge,
their weed-choked throats rigid, scabbed, decaying.
The faces eat and puke, puke and eat, singing
the high notes of *contritio* with pleasure.
In these thick-clotted diapasons of trills
and chirps, the dismal groans of lust are mixed,
then whinnying laughter, jeers—the music of Hell.

I miss my Joan buried now in an apron of silence.
I hold those years with arms bright and cold.
We sang each morning out of each night.
We laughed and built our world with melting snow.

FLIGHT INTO DEATH
in memory of Ted Hughes, who knew it would happen

Earth numb
the ground black as a mole
Roots becoming chains
Hills wallowing in dust
Snow smoking
The trees roar blind, swing blindly
Mountain water dammed to powerless sway
Oily sway
Fish churning their mud
The orchards and flowers stand in coma
Dry frost corn husked
A passing swipe of rain gone. Forever
The stillness like an iron nail driven flush to the head

The deer have loose red flapping suck mouths
Sheep fade humbly children lost
Mothers running in circles on the leash of cries
A tiny trickle of lizards
Four ducks in a dead line
Dogs run, muscles turn to iron torn lungs blood splattered chops

Builders
They trample the ripeness
Greed joggles the flowers
Blueprints an indecent din
Progress a daily premium
Builders
Their sins mingle grow
Prayers to blow torch godhead
Their minds like hulls blown from their mooring
Builders with their juvenile looks and delinquent eye
Closed faces of stone
Dust pressing into their skulls
Living in low rough corners

The smolder of man rising from the cities
Wombs cry furnaces
Knuckles explode
Insane now howling laughter into dead holes
Shopping baskets carry corpses with heron-pale eyes
Caskets of fire and stars

The springy bosom of the field gone they lift
Three geese under the sun's weight
Temperature rising climbing exploding
Blue skies now blue scorch
Everywhere roofs huddle, smoking
They fly above a time where no clocks agree
On the painful wind their glare cry
Sloping through kiteless skies
Panics fling them
Below Death's blossom grows then sets
A fruitless falling squawking surprising sorrows
Sudden bright cement towering
No place to land

Ghosts crowd, dense
Imagination's grail lost

THE HOUSE OF DEATH

The farmer watches
As old age reaches for its burnt sticks,
stirs its ashes,
and begins to sketch:
The farm sinks under its deformity
Windows sunken
Water falls down and labors
Wind a song on a lonely road
Birds dance the dance of unbeing
Sheep wailing in religious terror
Trees sheltering bulks, have nothing to say
The mountains fold
Light locked out by earth
Earth mutters it is good to be God
Night a sipping insect

Morning Sky hardened
Clocks walking home
The bends of the road lack a dimension
Words swallowed, like stones, voided
The womb an ugly grave, fallen in
Life is uplooking fear
Fossil ghosts wait
Death mews in the blankets—where is my kitten?

The House of Death
Open to all.

AFTER DEATH

Where will I go after they leave the room?
Will I rise, then settle, to mingle with the dust
on the pots and pans, or accidentally flushed
with the coffee grounds, to rise again, then settle,
to mingle with the dew on the rotting bloom?

DEATH *SHOULD* BE KIND

Death *should* be kind to ordinary folks.
Hands in pockets, getting by,
worn kitchens, old coats, cars coughing,
in and out of Safeway, but no safeplace,
puffy-eyed
from monster routines, busses grinding dust…

Quiet decencies laughed down;
yellow sun teased apart by a thousand chimneys;
brown growing browner;
days smeared with years' pitiless use;
the sky beating like Death's drum,
a self-absorbed light,
passing through the wry spirit's misery.

Torn from insipid summers, having escaped from Truth,
knowing to be without description is to be,
lost in an integration
of the martyr's bones,
joined now with a common sorrow,
they are together:
This is their first rest,
and, know this,
it is their best.

THE CITY, 2050

Bored by the powdery wipe of Nothing's hand,
the city holding no surprises inside ever again,
the people flutter like torn sails—
all out of luck and time. They have the sour smell
of rolling stock, maturing rust, emptying
out days brilliant and deep, moving slowly
but without resistance, no murmurs, coughing;
last crystallizations of all the city has denied,
threatened, lied to—those left behind huddle
into cold fireplaces, cold air flowing
across nipples, the odd unstomachable meal
thrown or vomited there or there, all forcing
time down to Absolute Zero:
Lie and wait, people,
and be quiet.

SUMMER SONATA

Upon my great big Adam's apple the weight of summer sat!
Summer seduction in the dressing of leaves
Sedulous hot yellow bells wild and soft self embraced
Fur and feather locked together (huddling infinite wishes)
Bare butts bald and bold
a juicy and jostling shock on rainbow footing.
Drifted gifts of featheriest slenderness ravening for earth and sky
Brittle marvelous breathing things;
how strangely life is curved
though mostly, unobserved.
Sunlight over the West plum purple shadows swim
Creeping along the air a fragile light bends gatheringly
The hours drum down to sunset
Cool treasures of silence explode into brightness of skylessness.
At peace within the wound
summer spins its spirit up into prayer-pale stars.

MEPHISTOPHELES—THE LAST VISIT

"Phoebus, arise! Use your filthy brush!"

I heard those words in a dream, an odd, foreboding
whispering dream. A dream still fresh, though now
it has been seventy years. A dream without
footholds for logic; guided by a cold
hand to a beach at dawn, tormented by
an ugly, lashing storm. Then the long sinuous
roar of the wind quieted. Sometimes we
cannot define our own life, our past does,
sometimes events, sometimes it is our name.
My name is Charles Faust, and this is the dream.

Far down the beach I saw what seemed to be
a bad-luck dog, a drifter, nipping at
its heels—then nothing, nothing at all, but
a smell, awful, like old female flesh, then
the musty odor of dry, dead leaves.
Jesus! Ahead, where the dog had been, a man
sat in a chair stroking a cat that looked
half-starved, one eye was gone, and it was shivering;
and then I heard that voice again, but singing.
The song was ghastly, guttural, it was,
I think, Zydeco, old verses, but in Cajun:

> "I shot down from starry height
> with brilliant, fiery charm;
> but I lie in the grass tonight:
> Who'll proffer me his arm?"

A barbarous dissonance gave way
to a loud, irreverent, catty voice:

> "My time was long, long ago, when Time
> was but a glint in Daddy's eyes!"

PART I

FAUST: *(with astonishment)*
What are you doing here, I mean, this storm…?

MEPHISTOPHELES: *(amused)*
Crocheting Time! No? Well,
La Porte de Enfer…

FAUST:
I don't speak French. Who are you? What's your name?

MEPHISTO:
Ah, right to the point! Not like your
great, great Grandfather. Now there was
a man who could talk! But this is better,
for I am tired, and this is my last visit.
Just a few things to say, and then, poof!

My name? Now that is a problem, for the list
is long, there is: "Belial," "Abaddon," "Sheda,"
"Ravana," "Condemnation," and more.
All quite lovely. Your famous relative
called me, well, no need to mention a rudeness.

You may call me "Shaitan," which is my favorite.
And I am He, He who the Other never
speaks; the tender point from which life slides,
the gentle force that issues from inside.
And we are together both, and both together.

There is much between you and I. You know who I am.

FAUST:
Yes, I know. And there are questions of course.
So, is this the time, do you have time?

MEPHISTO: *(laughing)*
Time? Now that I have charge of, time indeed.
Great time, mad time, quite bedevilled time!
There is time for this, and that, boundless time!
Time is the best we give, everything is
a matter of ripeness and of dear time.

Our gift is time, that thread like trickle of sand,
and who can see to the end? Forget the end.

FAUST: *(sitting on the wet sand, he smiles)*
Forget the end? You old charlatan, your art
is the pretence of truth and feeling, that much
I learned from the diary of the first Faust.
He said you take much pleasure from such tricks.
But now, questions, and silence is not your motto!

MEPHISTO: *(singing)*
Be careful!

> When once thou gavest to me
> At night the cooling draught,
> With poison didst undo me.
> Then on the wound the serpent
> Fastened and firmly sucked…

Man, all hope and impatience! Loves to pry!
Speculates on speculation; speculation
in the blood! Never guessing that knowledge
and corruption are one, the ambiguous and
ironic, the absolutely questionable, is
the highest passion, not the objective.

The artist knows, where but in pain and darkness
can he find the reckless courage, the audacity
to create? Enough. Proceed. Ask your questions.
But remember. The small lusts always bore me.

FAUST: *(a long pause)*
Heaven. What was it like? What happened there?

MEPHISTO:
At first it was silvery, windy, delicious.
I filled all space, "O Fairest Flower," it seems
now, only a moment, but truly, I loved it.
That was before it became Christ haunted, you see.
It seems all the gladness given was conditioned.

You see He forced the tone: "You won't make small
of Me," He screamed. All divinities have two
natures, and that defines the bounds of liberty.
And so he took away the light, and Brightness
fell from the air into the field of time.

It is the back side of the good times
that let you down. I fell, pushed really,
into that web of night, and it was cold,
not hot, as I, as you would have thought;
cold…and suddenly, I was so lonely.

FAUST:
And today? Heaven that is, what is it now?

MEPHISTO:
Who cares? Old, a bit worn, all those
officious lamps! Earth is lovelier. Why
did He not once consider the wisdom
of forgetting all about it? It's time
you took another look at this thing.
Odd, what you people never question!
If Heaven was so great, why did one half
the population rebel? Have you forgotten?
And over what? Adam. That *naturmensch*,
I spit the word! Those two! Heaving and wiggling!

Of course, there was the Christ, that was an issue.
Sure, He had it rough. I mean to be a babe
with burial before birth; sure, they laid Him
in the dirt. But on me treble confusion,
wrath and vengeance was poured. Now that's rough!

That so many followed Him, that made me pause…

FAUST: *(grinning)*
"In the beginning was the Word."
That *must* have been you!

MEPHISTO:
Charming lad. In the beginning was the Mind,
and that *was* me! So much to do back then:

 I was part of the part that once was everything,
 Part of the darkness that gave birth to light,
 That haughty light which envies mother night
 Her ancient rank and place and would be king…

But, today, there is so little to do.
Still, one does what one can: the vine rots
so the fruit may ripen, that sort of thing.
And yet, the songs of the Devil must be sung.
A noble duty to negate this world of fools!

Here are a few of the sweet excesses storming
Man, from the Lord of rats, mice, bedbugs and lice!

(sings lustily)
 Daddy's little girl has a fast red car,
 Daddy's little girl has a fast red car,
 Daddy's little girl has a foot like lead,
 Now daddy's little girl is stone cold dead!

"Let there be Light," He said, "The First of Things,"
"Let there be Rush," I said, "The Last of Things,"
Motion! A relentless pace, increases tendencies
to separation; how brilliant of me! True genius!
Motion and sensation push thought and sentiment out.
No more exploring the soul. A rose in your nose!
Impregnate them with urgency—now that's fucking!
Watch them rush right past every delight!
All motion blurs mystery; each breath of spring,
each treasure ignored, everyone in free-fall!

Of course, one must fine-tune these noble efforts,
in this work patience plays a part, nothing
but time can give the brew its strength. Now take
television, the shift (the nudge!) toward
the image, how many have I buried there!

Slogans and mockery; no more complex
meanings, but a nervous, continuous collage,
quickly used, soon spent. This truth is provisional,
a new reality, transience not permanence,
episodes not structures, theater not truth.
Now there was a lucky hit, the thread's flow
on, unseen and subtle, each blow affects
a thousand ties; but who can weave like me?
Nothing connects to nothing—and that is Hell!
(musing)
I will gut their institutions, soon even
the Law will disappear into the screen!

How you love to suffer! You lost passion
for your own laws, you wrap your legs around
relativism, and values become opinions;
you outcast restraint, the notion of yielding.
An absolute egotism negates
reason and decency; your Press aspires
to true power, though no one elected it.
You put yourself at the center of the world,
so death becomes the end of all things.
Without signposts all roads lead to exhaustion.

PART II

MEPHISTO:
I still remember that last moment, He
lunged at me, as though to kiss me,
and I fell backwards, hearing only His words,
those last words. And then with mighty arms outspread
dove-like, he drove me down. And so I became
He who is not, except I am. Beaten
into a night within the night. This place
of impotence and extremity; protected
from speech, but by my word it is there
everything ends, everything altogether.

The lost implore, "you verily cannot do so
unto a soul:" it is done, it happens, and there
is no reckoning in words, not here, far below
God's hearing, here in this soundless cellar.
Between thick walls it gets right loud, measurelessly
loud, the expected screeching and beseeching,
gurgling and groaning to be sure, but something
more: a clotted diapason of trills and chirps,
the dismal groans of lust. You see, endless
torment, with no collapse, degenerates
into shameful pleasure, the "lusts of hell."
And there it is, the bliss of hell, a deep-voiced
pitiful jeering, whinnying laughter, the pointing
of finger. Believe me, the finest and proudest,
who never once swore, say the filthiest of all.

You see, Charles, all evil is fatigue.
But, what do I know? I am not quite
the boss; there are many small hells, some
quite private. You sought God, with me you are
awfully close, perhaps that is close enough?
Charles, forget goodness! Goodness is like
spooning spit into your mouth! And do not think!
Ideas are a bad lot, they have hot cheeks,
they make your own burn too, and not in a
lovely way; this swing of yours between
penitential paralysis and compensating
release! Oh, Charles, the mission bells are
ringing in Kansas for your pissy attitude!
Watch with me! Be about me at my hour!

FAUST:
And then he changed. Before, well, something kept
me from seeing him clearly. Odd, but true.
I do remember dimples, one in his
chin, one in his left cheek, and dark, reddened
eyes gleaming with moisture, but nothing else.

But now. He became smaller, and entirely visible.
A rugged face, as though shaped by a dull
hatchet, pink eyes, a drooping nose with wry tip.
A cheap checkered coat, sleeves too short, sausage
fingers coming too far out, pants indecently tight.
He pointed, there was that bad-luck dog again,
walking into the ocean. Then he sang:

MEPHISTO: *(singing)*
> And only one, a puppy dog,
> listened till silence fell;
> and when he got back to his home
> that dog felt far from well.

How well I remember old Faust. That shameless
scum! Telling me that even in that pit
I would cause him to shiver forever!
Your great, great granddaddy spoke those words
running, his tail between his legs, stung
by his genteel genius for flirtation!
Talk! Talk! Talk! How that old fart could ask
questions! What is Hell? I told him one can
really not speak of it at all, many
words can be used, but all together they
are but tokens. The secret delight and security
of Hell is that it is protected from speech.

Just come with me! He will never notice!
You will still have faith, religion after all
is my line! We offer only what is right
and true, the primeval, that which is still untried.

FAUST:
A strand of hair lifted, as though from hot air.
His soft, thin hands reached out and stroked my hair.
He changed, the way clouds do, and then, gone.

Shut up! Sit!
Sit! You clipped-winged piss-pots!

He will come. For him the hour-glass is set,
the red sand runs through the fine-fine neck.
He tripped over a nice, neutral middle point,
and never felt the fall. Tonight, in a
drunken bliss he savours his silent escape,
believing his wit identical to a wine
aged a thousand years! But he will come.
For I have sent to him my little ones.
My tender little ones, swarms of busy
corkscrews, the *spirochaeta pallida*.
He rots away, liver, kidneys, stomach,
heart, bowels; and then, well, my little ones
have a passion for the upper story,
the head, the meninges, the dura mater,
the tentorium, the pia, protecting the parenchyma.

In a few years our friend will bring forth
cynical quips. Then blasphemies. Then death.
His carcass will not go to consecrated
earth, but on the horse-dung with the
cadavers of dead animals. Come, watch.

THAT LAST POET

That last poet staring at an empty hall.
His words seep slowly to the core of grief.
The place old, wintery, skulkingly mean,
shouldering out the pockets of warm air.
No place to go but back into the poem.

The poem rots within a strict, gray industry.
The schools choose from an imperious palette.
The tree-lined paths are white with dust, and the leaves
of the trees have a nervous, spinsterish quiet.
Hearts learn to die well that have died before.

The darkness closing round a fisherman's oar.
The simple plants turning to the shores of light.
A white rain drawing its net along the coast.
Three graying women sewing under eaves.
All this has been banished into the incredulous past.

ENDINGS

It is an odd feeling to know you have
traveled across the landscape of your work.
Poems written now fall down between my chair.
Words have gone from dark to blazing light,
and back to dark. Words come, but die in the air.

Once my rhythm rocked the page, but now
paper ignores my hand, it fears the lead.
My gifts are random, wasted, and dispersed;
like mice, my metaphors caper in the straw.
And so my special heaven is reversed.

I have now walked this field for sixty years.
The wind still bends the grass beneath my feet,
but now it blows stronger, and at my back.
The weeds are tougher, and have their way with me.
I sigh before I sing, knowing what I lack.

LAST DAYS

I stare into the night these days.
Something dark moves away from me,
and that is me. Of course, it is
the way of time, for me and you,
to drag us back, through sagging mouths,
and drool, to parodies of childhood.

Each day there is a sense of falling.
Each night alone with white-star silence,
and thin continuous dreaming.
Not knowing how this or that, not
hearing who, now scolds me, rocking
here at the quiet limit of the world.

Some sights seem to belong to me.
A crow hit by a car lies dead.
One feather sticks up and flutters.
Its mate, confused, struts struts around
the body, both, for once, silent.
He and I know nightmares have no sound.

The last long day weakens; the past
moans with many voices; then death

Too quick to catch the eye of time.